Curious Distortions
Paintings and Sculpture by Mary Spain

ARTneo
the museum of northeast ohio art

Published by ARTneo, Cleveland, OH

Introduction by Barbara Christian
Essay by Douglas Max Utter

Design: Christopher L. Richards
Photography: Christopher L. Richards
 Portrait of Mary Spain by: J. David Wilder

© Copyright 2016, ARTneo: the museum of northeast ohio art
1305 W. 80th St, Cleveland, OH 44107
www.artneo.org

Staff
John Farina, Executive Director
Christopher L. Richards, Curator and Collection Manager

Board of Directors
Joan Brickley, President
Jon S. Logan, DPM, Vice President
James Heusinger, Vice President
John Wasko, CPA, Treasurer
Melanie J. Boyd, Secretary

Anna Arnold
Daniel Bush
William Busta
David Carney
Kenneth Hegyes
Sabine Kretzschmar
Betsi Morris
Robert Thurmer
Sheri Walter

Lenders to the exhibition
Canton Museum of Art
Betsy Colie and Tim Gleason
Jenny Gibson
Jean and Paul Ingalls
Rachel Davis Fine Arts
Heidi Robb
Jeff and Cheryl Shug
Jon and Rochelle Straffon
Wolfs Gallery

ARTneo programming is made possible by memberships and support from:
The Ohio Arts Council, The George Gund Foundation, The William and Gertrude Frohring Foundation, The Robert and Sally Gries Family Foundation, The Cleveland Foundation, AG Foundation, The David and Inez Myers Foundation.

Curious Distortions
Paintings and Sculpture by Mary Spain

Mary Spain (1943–1983)

Presented by ARTneo: the museum of northeast ohio art

October 16, 2015–January 15, 2016

Curated by Rachel Davis and Chirstopher L. Richards
With an introduction by Barbara Christian and an essay by Douglas Max Utter

Acknowledgements

Set in a realm of fantasy, Mary Spain's work exhibits oddly distorted figures in a child-like manner with an underlying sense of absurdity. Through her toy-like and primitive style, Spain created surrealistic dramas that puzzle and entrance the viewer. During her struggle with cancer, Spain used these figures to express her feelings of pain and sadness. While her deeply personal vocabulary and symbolism might be lost to the viewer, the narratives and embedded emotional substance remain.

The planning of this exhibition required a great deal of input and research. Rachel Davis and I discussed this project at length prior to its being included in ARTneo's exhibition schedule. She was instrumental in locating works and putting me in touch with Spain's daughter, Betsy Colie. Without Betsy's enthusiasm and support, we would have been unable to pull together the amount of in-depth research and the number of high-quality works still in the collections of friends and family of Mary Spain.

I would like to thank all of our lenders, whose generosity has allowed ARTneo to present the first large scale exhibition of the works of Mary Spain in well over a decade. I would also like to acknowledge John Farina, ARTneo's executive director and our Board of Directors for their continued support of the museum in presenting engaging and thought-provoking exhibitions to the public.

Christopher L. Richards, curator

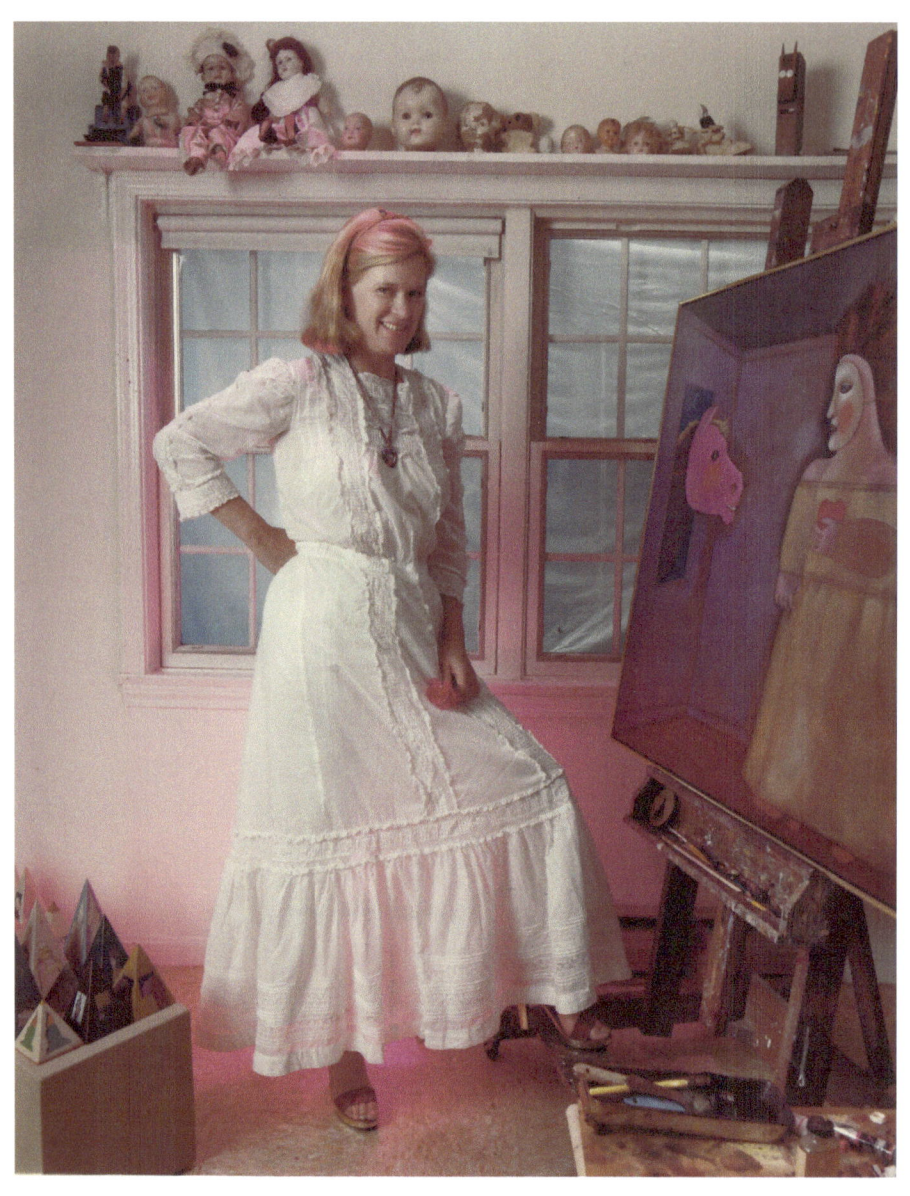

Mary Spain (1934—1983)
Photograph by J. David Wilder

Introduction
Mystery Still Enshrouds Painter
by Barbara Christian

There was something about Mary. Ask any one of her friends. Some of us are still around. Mary had charisma, she was funny, mysterious, and a painter of mysteriously funny things.

She had the heart of a Bohemian and the wardrobe of a suburban housewife. Mary favored skirts and cardigan sweaters and wore a headband in her blond shoulder-length hair. It was a disguise.

Mary was a demon painter, and I would challenge anyone to match what they saw on the outside to the haunting images painted by her inside self.

Part of her mystique was Mary never talked about her work or the meanings of the symbols and the code she worked into her paintings—the cats, the masks, the ever-present triangles. It didn't seem to matter, or maybe she didn't know.

If you happened to turn up in her studio while she was working on a painting, she might nod her head toward the easel and ask what you thought. Looking back, maybe she wanted to know or needed insight into her own psychology.

Here are some things we do know about Mary. She taught art at Chagrin Falls High School for a short time. She lived in Solon with her husband, a part-time Chagrin Falls volunteer fireman. They had two daughters.

She was very funny, could be outrageous and had a sneaky laugh bordering on witchy. She was a prankster but in a good way.

Here's an example. The weekend before an open house for a house we were selling, Mary said what the place needed was some oomph. While we were gone, she let herself into the house, convinced the kids it was OK, then hung her paintings on every wall. We loved it, but potential buyers seemed, well, distracted.

Then there was the dinner party at Mary's that ended with everyone feeling good and deciding to write or draw tributes to life and art on her damask tablecloth. It may have been an heirloom. She didn't mind. Mary valued "creativity" more than the tablecloth. She swore to have it framed.

Mary was so many things. Zany? To be sure. But she was also studying Judaism on her way to converting to the religion. She never did. Mary never got to be an old woman or the famous

painter she was on her way to becoming either. Mary died of cancer in 1983. She was just 49. I think about Mary often, but lately she's been haunting me more than usual. I found myself driving by her house; a friend sent a gallery listing for the exhibition at ARTneo; I came across an auction notice featuring several pieces of her work.

Cleaning out a closet, I found a pair of 4-inch-heel silver sandals. Mary's husband brought them over with some other things sometime after she died. She had chosen pieces from her wardrobe she thought her friends would like.

The silver sandals were puzzling. I would never wear such things, and she knew it. Maybe she just wanted me to have a laugh. Then I wondered what Mary, my skirt-and-cardigan, headband-wearing friend, was doing with them. Another unsolved Mary mystery.

I have never believed in the supernatural, but all this Mary activity lately has me wondering. Just wish, if she had something to say, she would just come out with it. But then that's Mary. Always interested in what you think she is trying to say.

Barbara Christian is a columnist for the *Chagrin Valley Times*. An earlier version of this essay appeared in the *Chagrin Valley Times* column *Window on Mainstreet* on 11.4.2015.

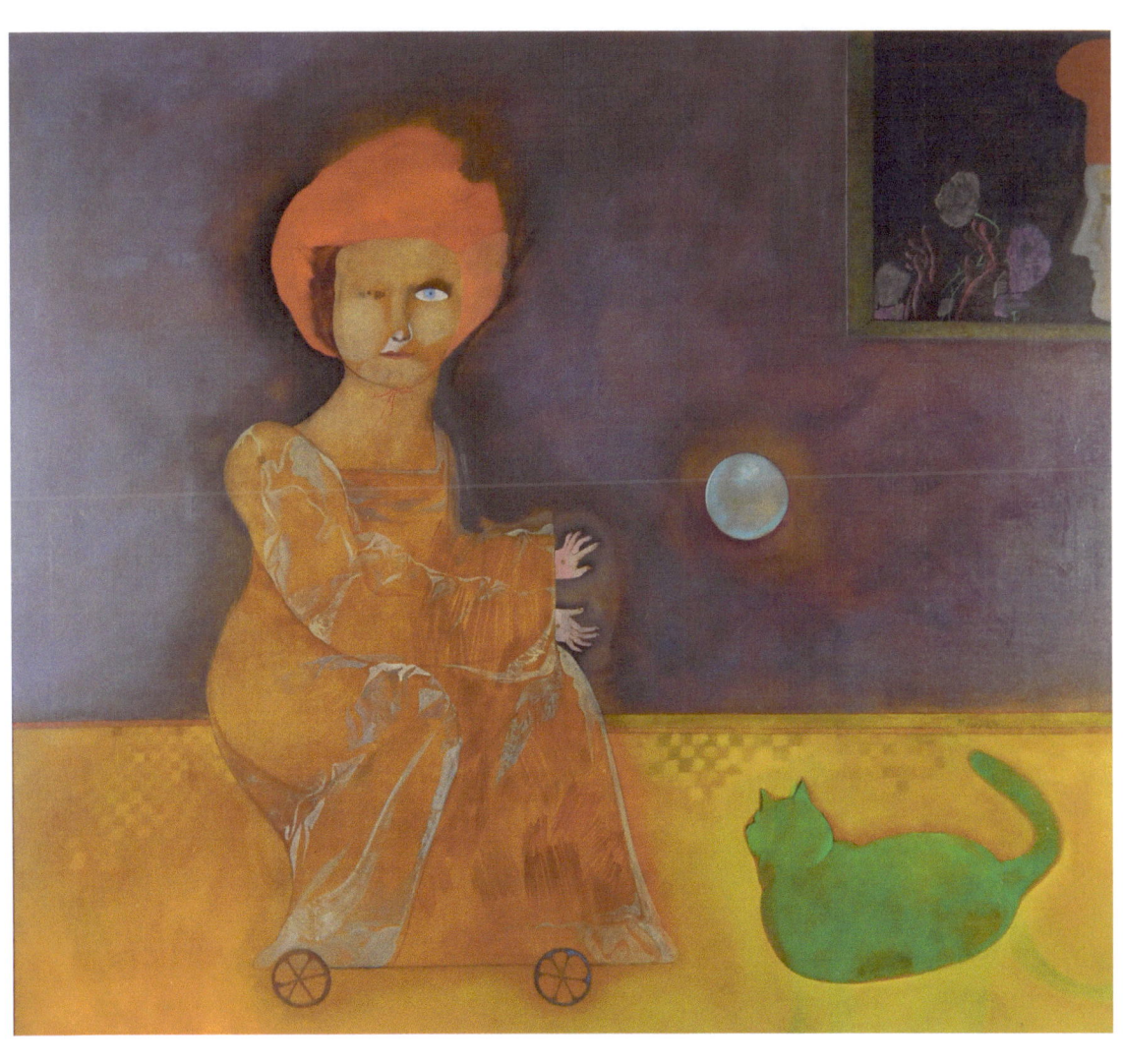

Man and Woman Playing Ball with the Moon, 1970s
Oil on canvas, 48 x 54 in.
Courtesy of Wolfs Gallery

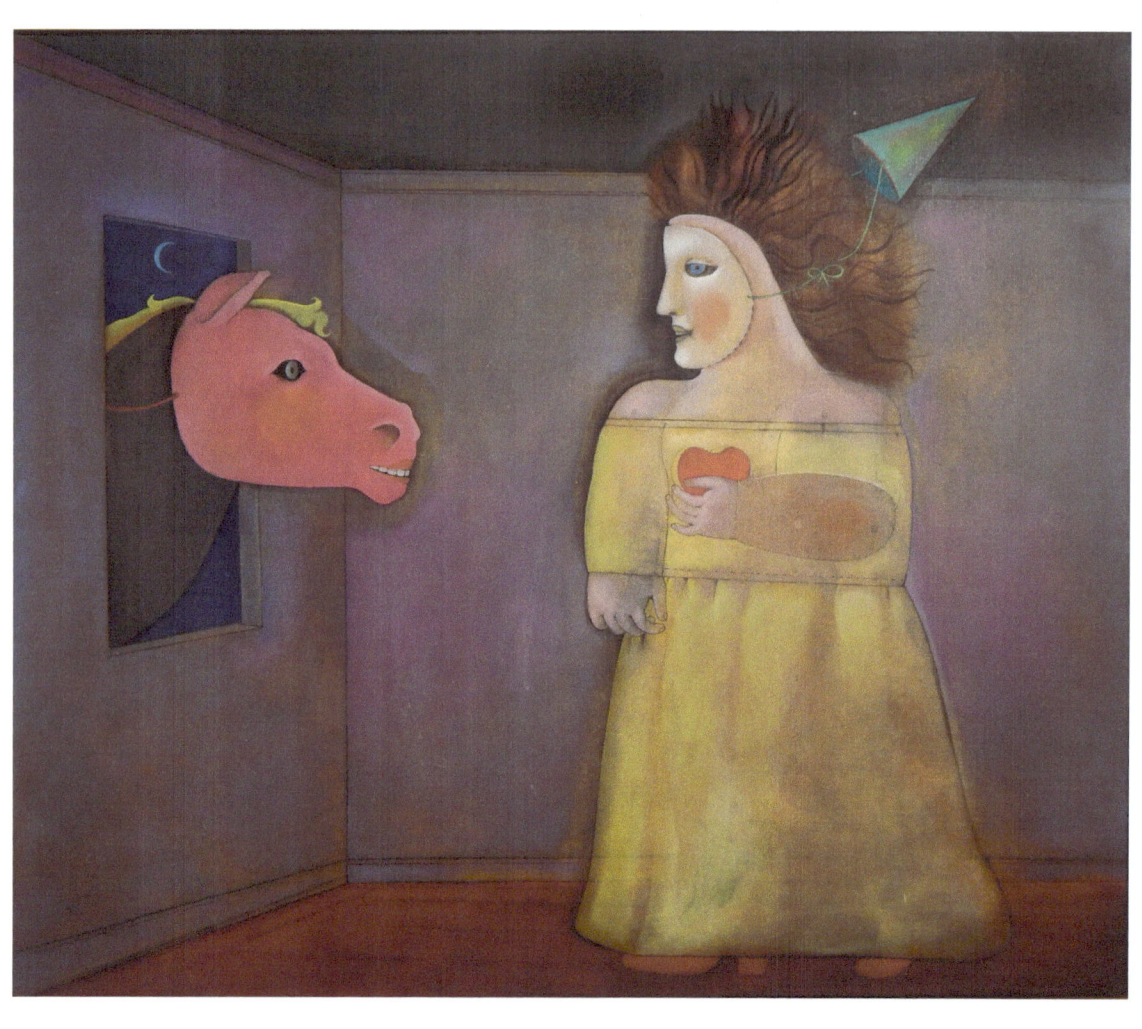

Girl with Horse at Window, 1970s
Oil on canvas, 40 x 48 in.
Courtesy of Rachel Davis Fine Arts

A Little Magic / The Art of Mary Spain
By Douglas Max Utter

"Art is magic and I think more people ought to try doing it. Everybody should have a little magic in their lives." —Mary Spain

Mary Spain was an artist whose visions inspired wonder and affection in her fans, and perhaps a certain anxiety. Works in her one-person shows in Cleveland, New York, and Ft. Lauderdale sold briskly, as if collectors feared her paintings might disappear—from the marketplace, if not from the wall. It was also true that her output was never very large. A reporter was informed by the Carone Gallery which represented her exclusively in southern Florida that she showed up every year with about six paintings. Her period of greatest activity as an artist lasted for about fifteen years, and her output included many delightful drawings and handmade, toy-like art objects as well as finished paintings, some of which were included in ARTneo's recent exhibition *Curious Distortions: Paintings and Sculpture of Mary Spain*. There is no catalogue raisonné for Spain, but her total output was relatively small and for those who are aware of her work, unforgettable.

Mary Spain and her husband Frederick Colie lived near Cleveland in Solon, Ohio during the 1970's with their two daughters. Spain taught high school art in nearby Chagrin Falls, building a solid regional reputation during those years. She earned her first award at the Cleveland Museum of Art's May Show in 1969, and many others in that show and other significant Ohio exhibits all through the 1970's. She was diagnosed with cancer in 1982, after which her illness progressed quickly. She died less than a year later in April, 1983 at the age of forty-nine. Following that early, tragic death, the half-life preserved in her art began almost immediately. Indeed Spain passed away the day before the opening of her first major retrospective, held at Ursuline College's Wasmer Gallery where forty of her paintings were on display. Three decades later her brood of artworks is scattered in homes and institutions, galleries and auction houses around the country.

Spain's tableaux can be mysterious, communicating with a visual stagecraft that slips past the eye on initial viewings. Composed of one or more figures, human or animal, often showing screws and loops that fasten their limbs to each other, they seem like the dreams of marionettes or the reveries of toys. Or they depict mystic visitations. In *Girl with Horse at Window* a make-believe horse wearing a pink flesh-colored horse mask (but with human lips and teeth), protrudes its head through a window into a room. In the room stands an oddly proportioned girl or doll, with a very large head and square body, wearing a pale yellow dress and a mask which, for all we can tell, could be her only face. Is there a girl under this womanish girl mask? Is there a horse under the horse/man mask? The girl/woman/doll wears a party hat, a conical hat, a lunar

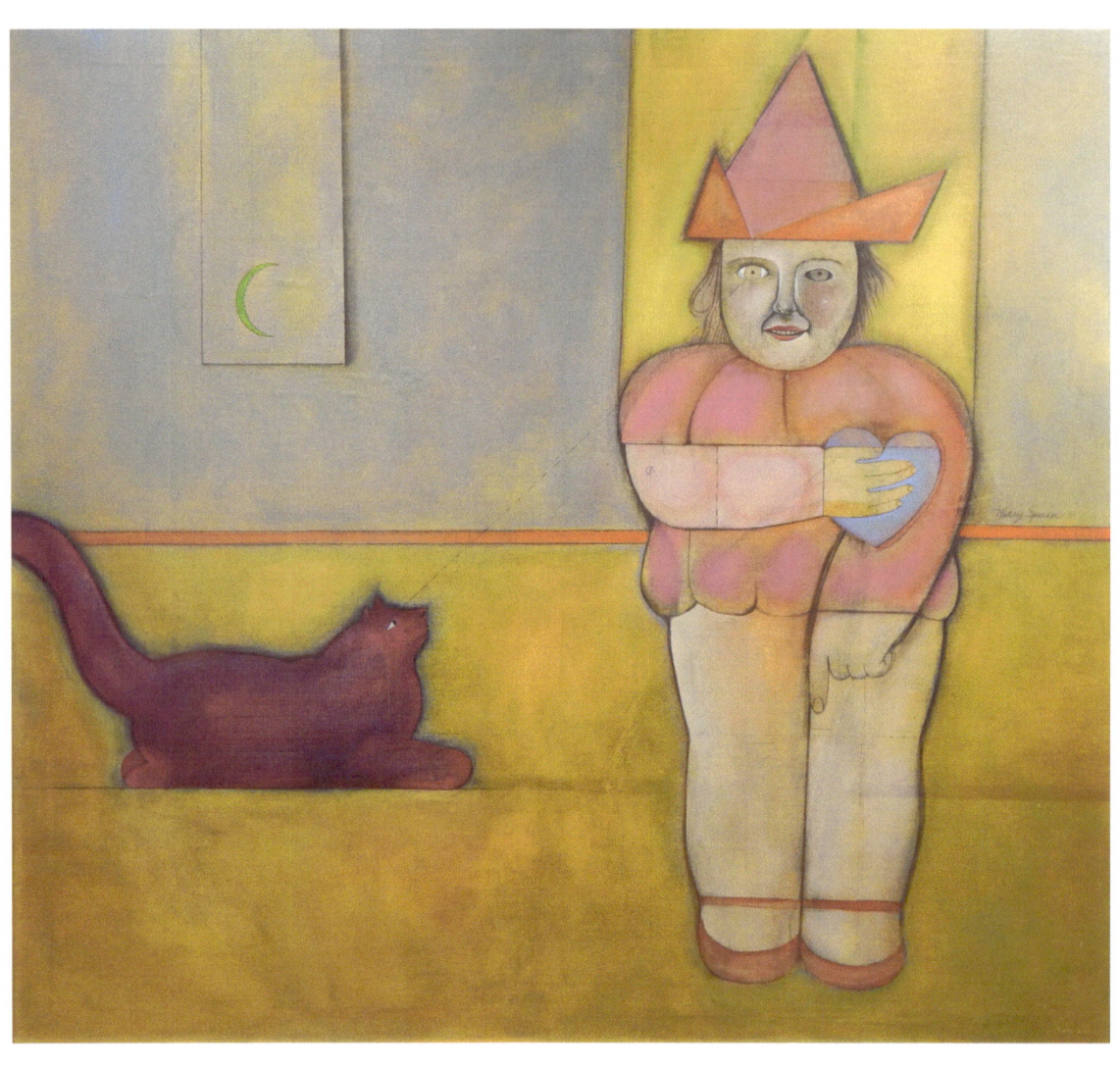

Boy with a Mechanical Cat, 1981
Oil on canvas, 36 x 40 in.
Courtesy of Rachel Davis Fine Arts

hat, according to age-old symbolic usage; or she doesn't quite wear it, since it floats off the back of her head on a chin strap, into the spreading brown cloud of her hair. The young moon itself, as a crescent, shines outside and can be seen above the horse's head, beyond his curly yellow mane. Just in the center of the canvas the girl holds a heart in her hand. Most difficult to fully to appreciate in reproduction is the richness of paint application throughout—scumbled layers of color and glaze sink behind the girl like walls of smoke, as her dress falls in a filmy cascade. This tryst or encounter is not only dream-like, but seems theatrical or religious. It takes place in a stagey, box-like room, and the participants are not merely themselves, but characters or symbolic presences. They are gods or archetypes, surely, though playful ones, concealing psychological weight and mature power beneath blithe masks and fables. The painting tells a toy story, deeply shadowed by adult thought and experience. Spain's interest in religion paralleled her art studies for much of her life. Her BFA from Syracuse University was in painting, but she also studied Judaism and Jewish philosophy for many years at the Laura and Alvin Siegal College of Jewish Studies in Cleveland.

Boy with a Mechanical Cat depicts another sort of visitation. A flat-bottomed cat with a muscular tail sits on a line on the floor and looks up at a little girl, or again, maybe it's a doll. Half of this hybrid child's height is made up of her columnar legs, pressed together and terminating in light red Mary Janes. A very short pink dress continues up to her chin. She reaches across with her right hand and presses a blue heart against her left arm, which hangs down; her left forefinger points to the bottom of the canvas. She's chubby, with apple cheeks; she appears to wear a paper hat, or maybe it's an abstraction, a tricorn of triangles. As in many of Spain's full face depictions, the eyes don't match—one has a white iris, the other is a dark gray. One looks inward toward hidden motivations and histories, the other looks out, into our world.. That there is an imbalance or an illness of some kind is clear from the disproportion of her hat, and from the scraggly hair poking out from under it on her "dark" side. Spain's technique also indicates the nearness of sub-surface secrets. Throughout the artist paints as if creating a sort of palimpsest, wiping and scrubbing her images until they're semi-transparent. They're almost ghosts, perhaps, or Spain intends that the painting itself should appear very old, like a soul after many incarnations. Even the window-shapes in this work reinforce the overall inwardness of the piece—on examination one proves to be a painting of the moon, and the other is a yellow screen.

Knowing that some of the work in *Curious Distortions* was completed not long before Spain's death makes it an almost too easy to read some of her works as fateful premonitions. Her 1983 *Man Hanging Upside Down and Amaryllis* must be one of her last finished paintings (it was included in CMA's May Show as she lay in her hospital bed) is a deliberate version of the Tarot Major Arcanum known as "The Hanged Man," often interpreted to prefigure either death itself or profound, but willing spiritual transformation. The performer figure who takes center stage

here is clad in a billowing circus-ish white outfit; he smiles as he tips his halo-colored hat. A ladder leans against the wall behind him. Unlike the sacrificial figure in Tarot, he isn't bound, but hangs on to the lavender rope by his own one-handed grip. At the top of the wall an amaryllis spreads its petals, suggesting yet another symbolic narrative. In the Greek myth, a girl fell in love with a shepherd and gave her heart's blood for his affection, which gave rise to the amaryllis. Unlike many other obviously romantic compositions by Spain, this one does not show a literal heart, perhaps because the central character's hands are engaged in other symbolism. Instead the flower waits beyond the wall, gesturing downward with one petal like the pointing finger in *Mechanical Cat*. On the other side of the canvas at the top of the wall, a dog keeps watch, guarding the dreamer, or the dream.

Above the dog the moon shines. The painting is so light, it could be a daytime moon. Asked why there was always a moon in her work, Spain told a Fort Lauderdale columnist, "It's a way of keeping some order in the universe." Its presence warns of deception, promises beauty. It tells us to look harder, that lies are told and much truth is hidden. At length, near the bottom of the *Man Hanging Upside Down*, we notice something unusual. Just visible beneath the figure's mask, where the doffed hat would have completed the disguise, is the sunset-shaded, domed head, and the eyes, of another man underneath. In many of Spain's deeply poetic images, there is a sense that the painter's hand and process know more about the heart and the uncertain future than even the artist herself, betraying a glimpse of hidden, fateful things.

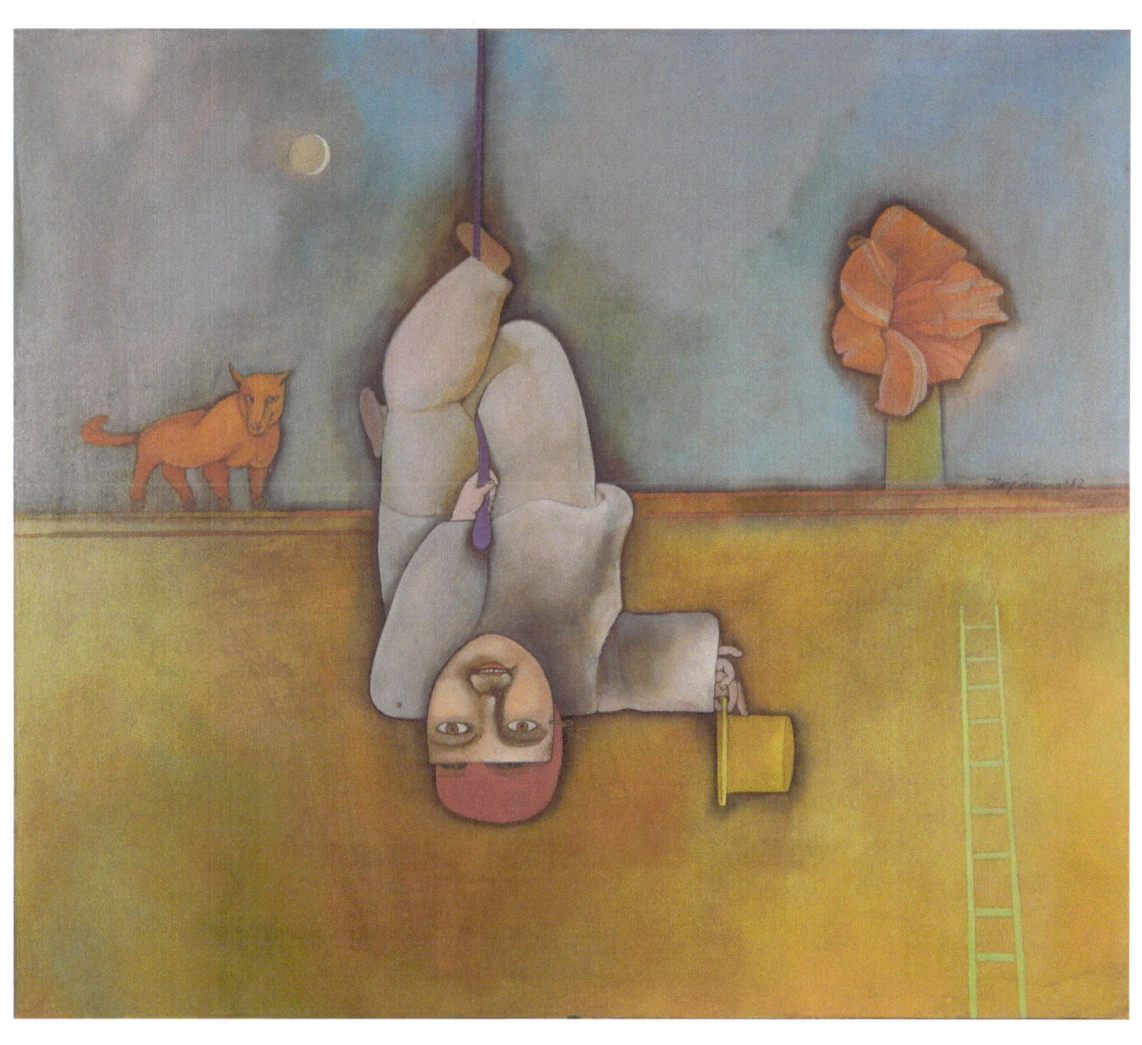

Man Hanging Upside Down and Amaryllis, 1982
Oil on canvas, 36 x 42 in.
Collection of Betsy Colie and Tim Gleason

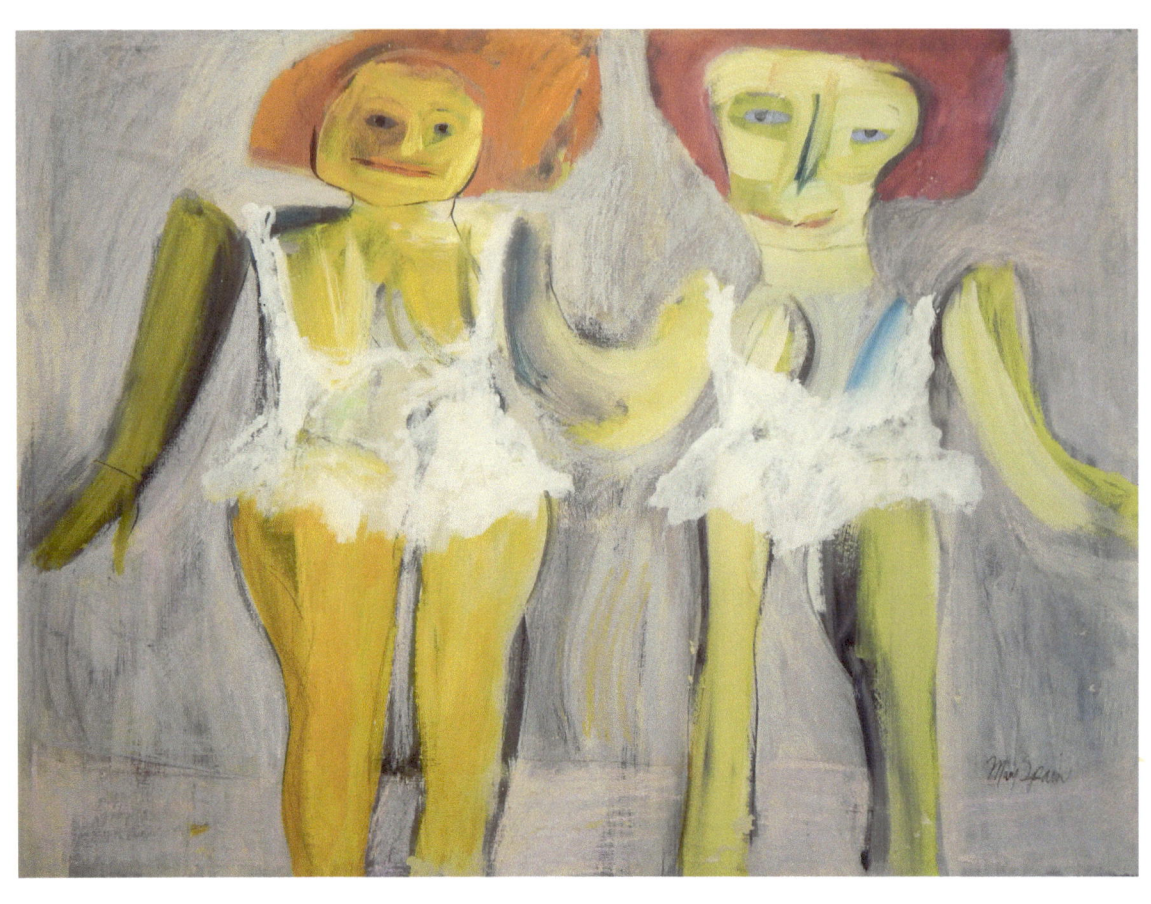

2 Sisters, 1972
Oil on canvas, 35 x 48 in.
Collection of Heidi Robb

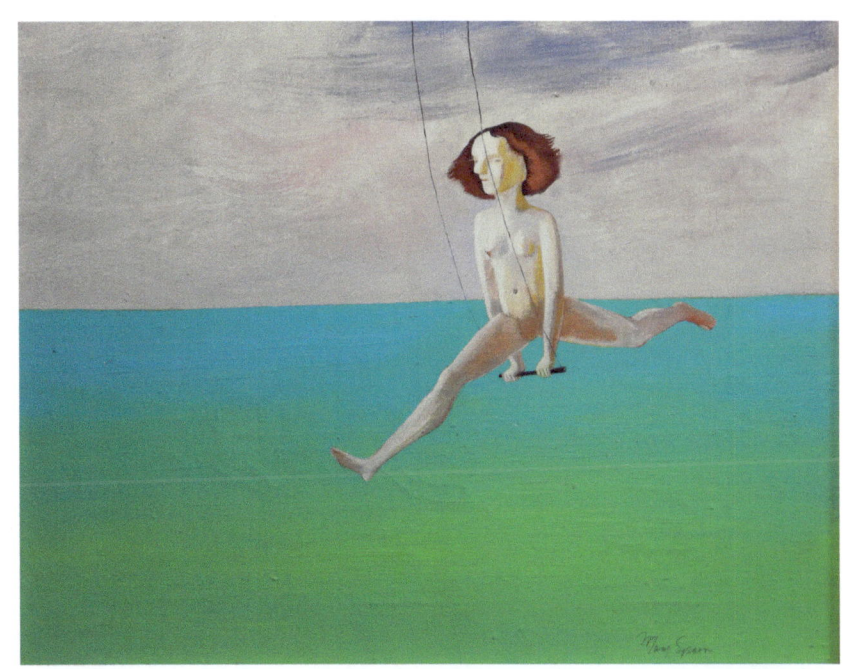

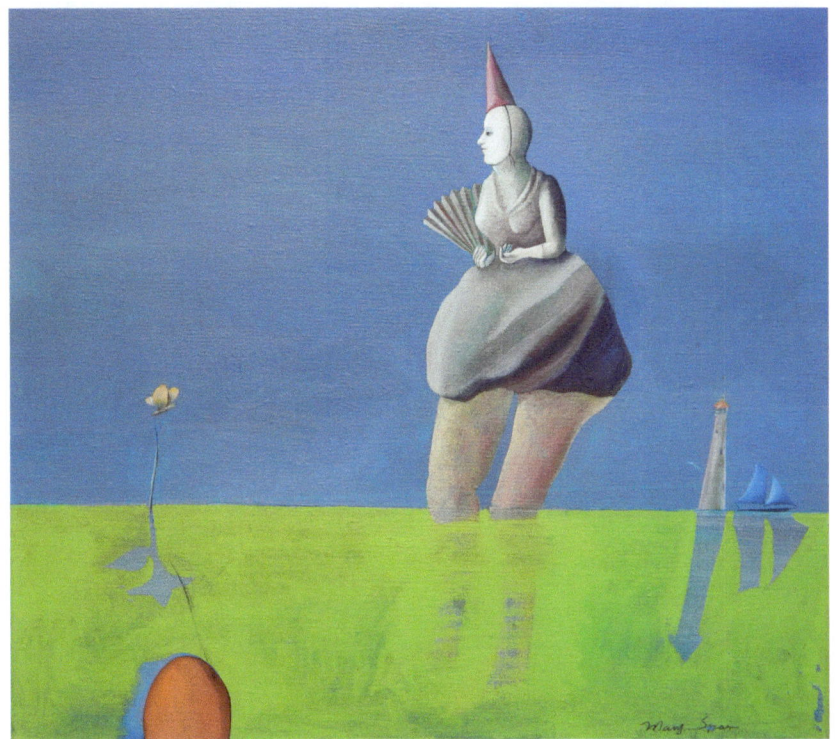

Woman in Flight, 1973
Acrylic on canvas, 14 x 17.5 in.
Collection of Heidi Robb

Girl with Fan and Butterfly, 1970s
Acrylic on canvas, 16 x 18 in.
Collection of Heidi Robb

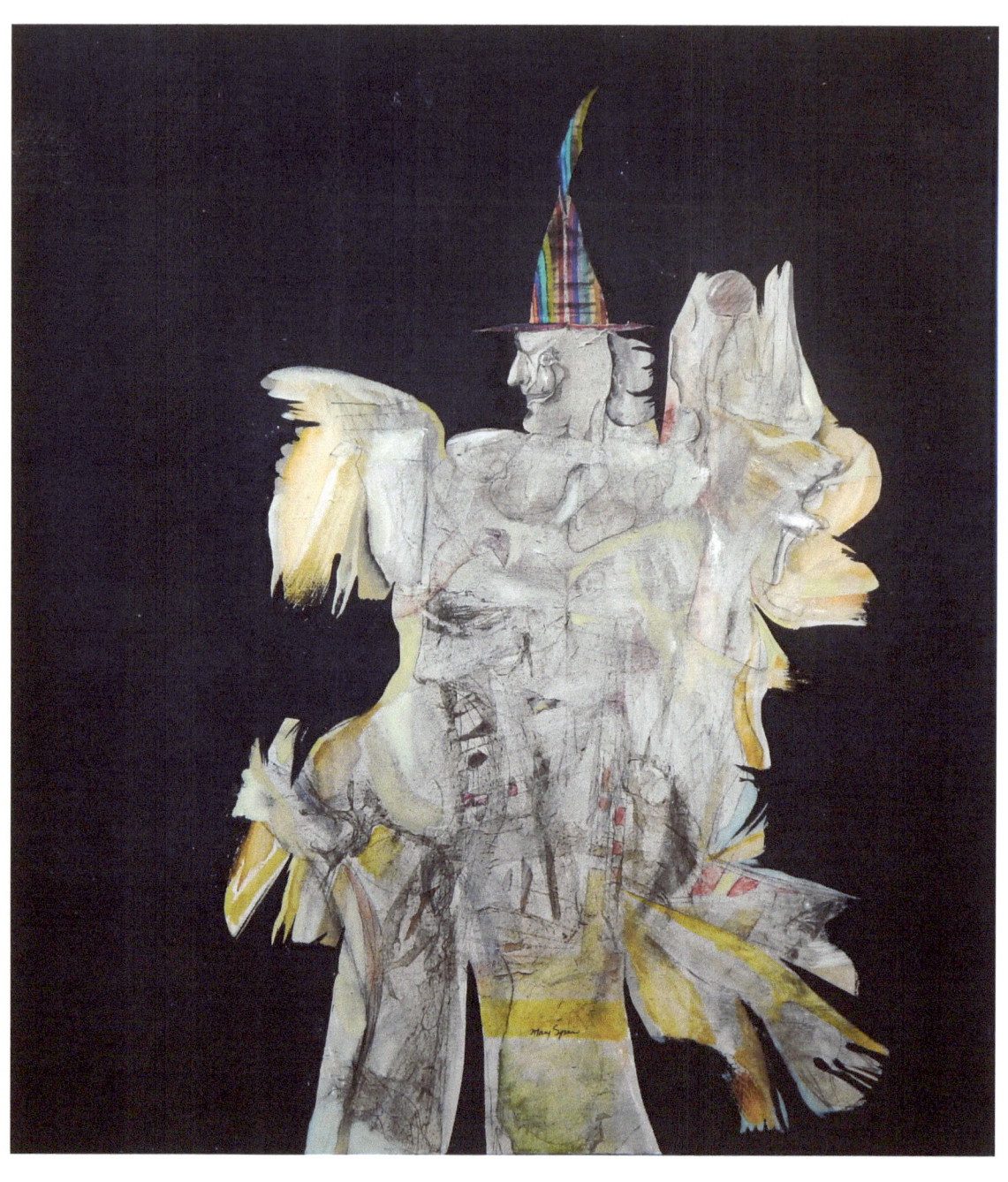

Rag Man, 1974
Oil, graphite, and collage on canvas, 40 x 36 in.
Collection of Jeff and Cheryl Schug

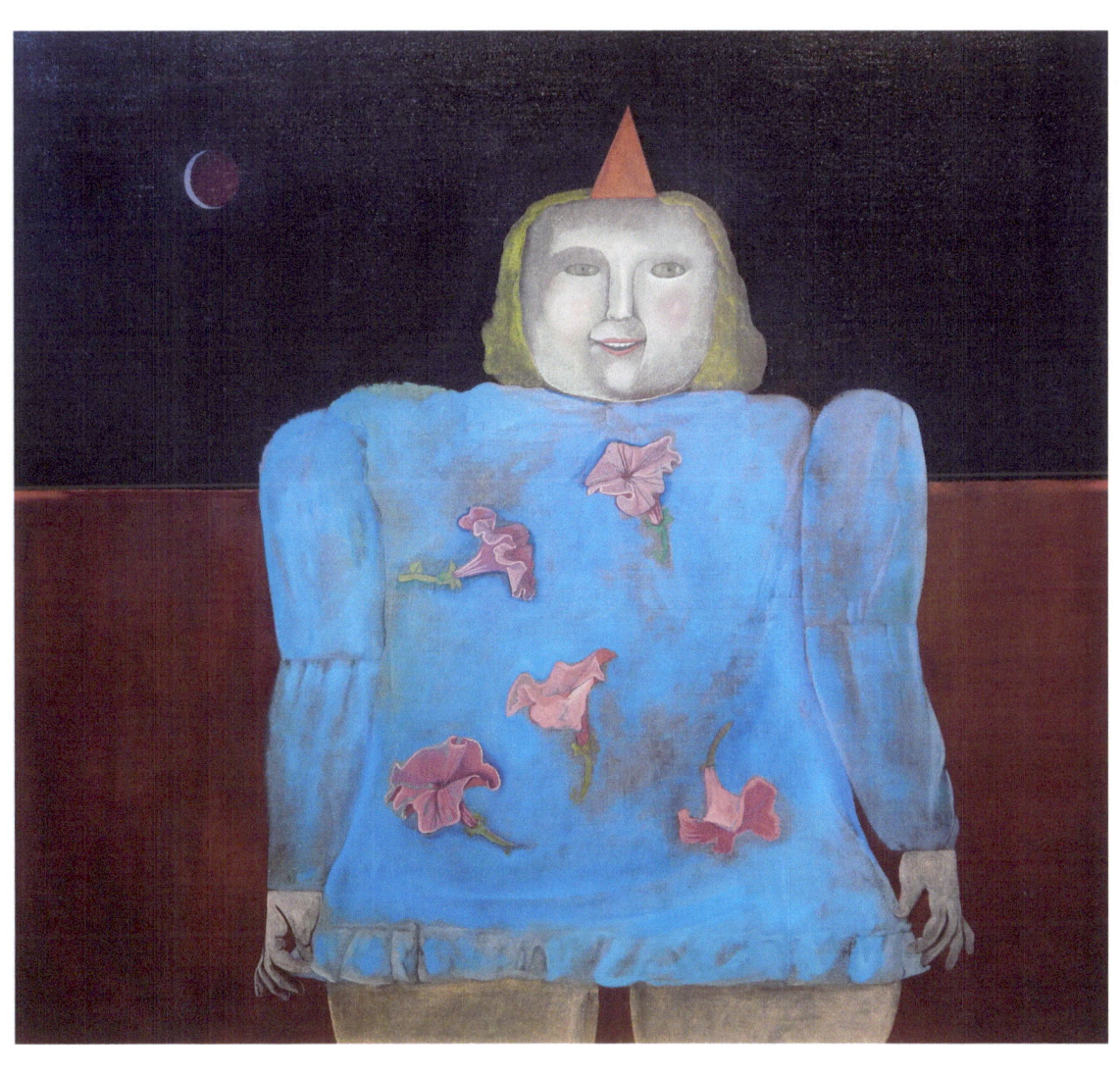

Girl Tossing Purple Petunias in Her Dress, 1982
Oil on canvas, 36 x 40 in.
Collection of Jon and Rochelle Straffon

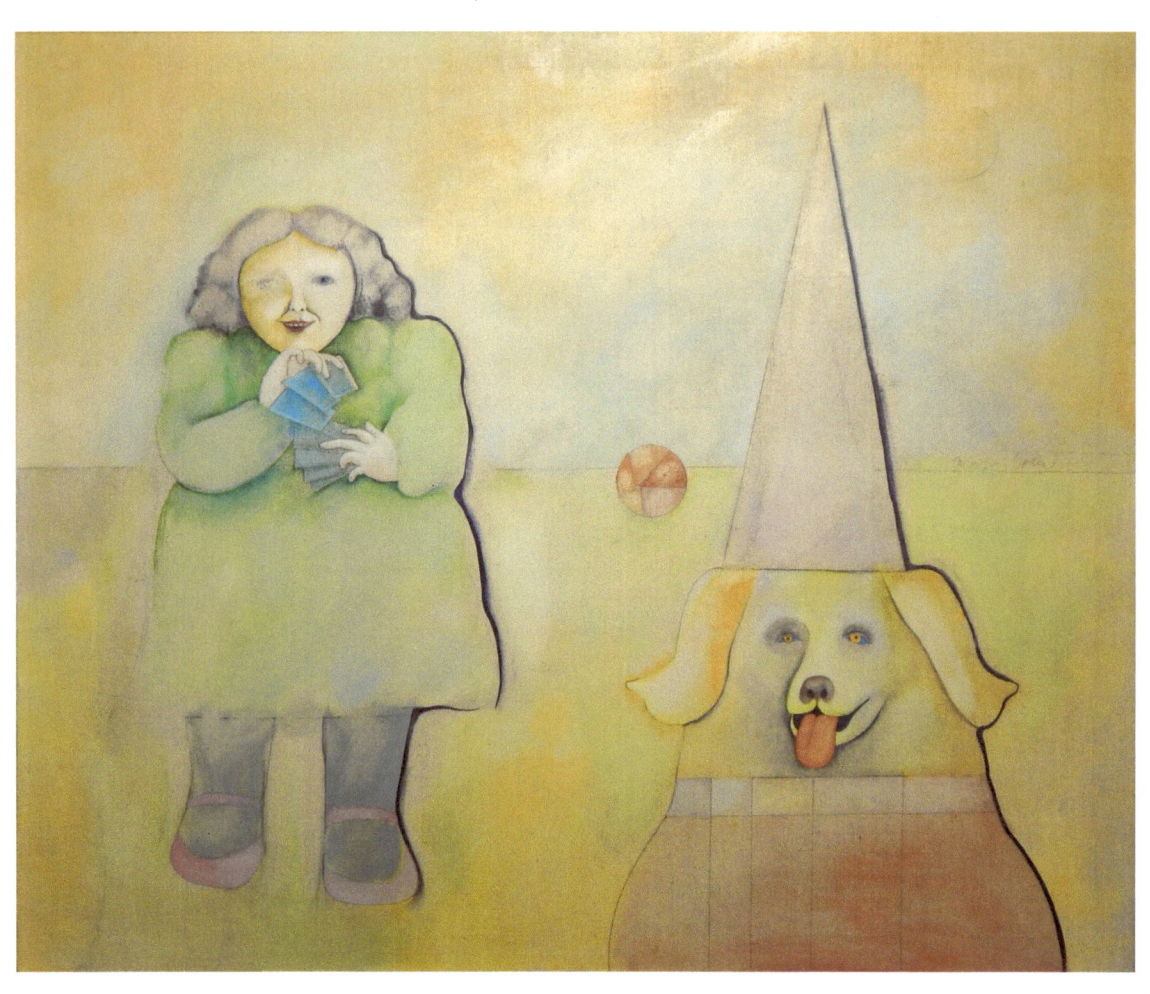

Heidi and Steve Playing Cards, 1970s
Oil and graphite on canvas, 36 x 44 in.
Collection of Jean and Paul Ingalls

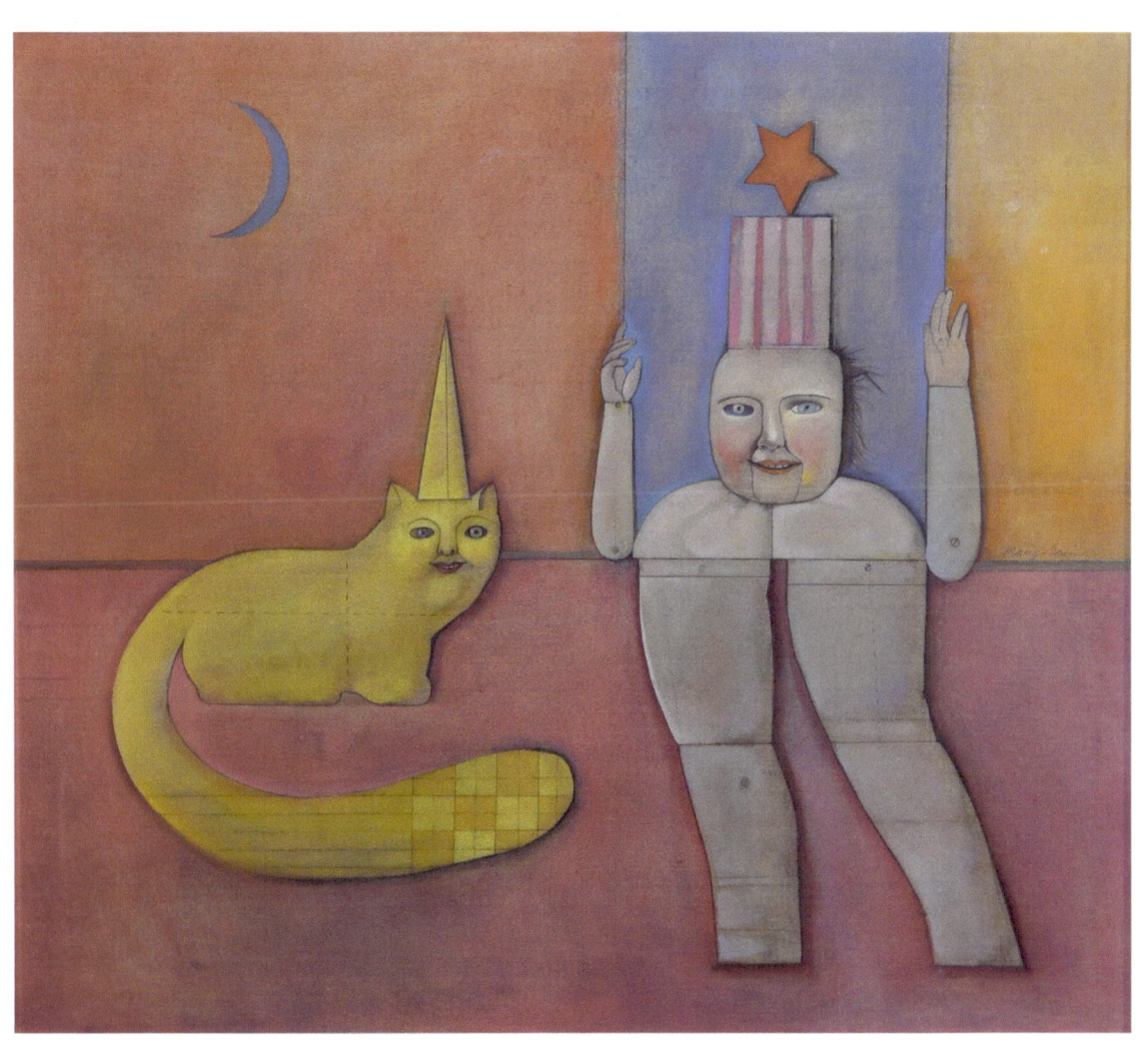

Hanging Clown with Yellow Cat, 1970s
Oil and graphite on canvas, 25.5 x 29.5 in.
Canton Museum of Art Collection

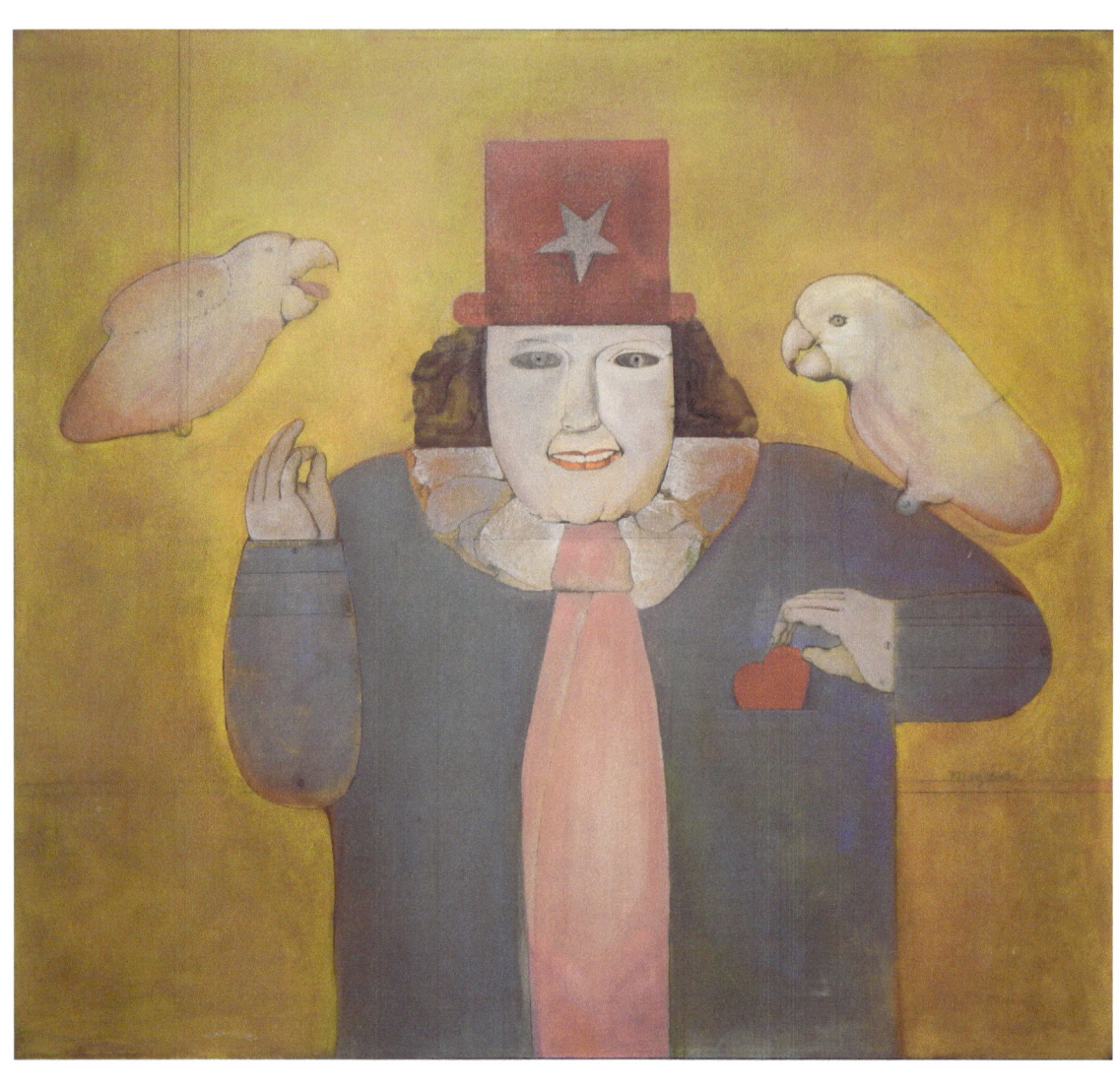

Magician and 2 White Parrots, 1970s
Oil and graphite on canvas, 36 x 40 in.
Courtesy of Wolfs Gallery

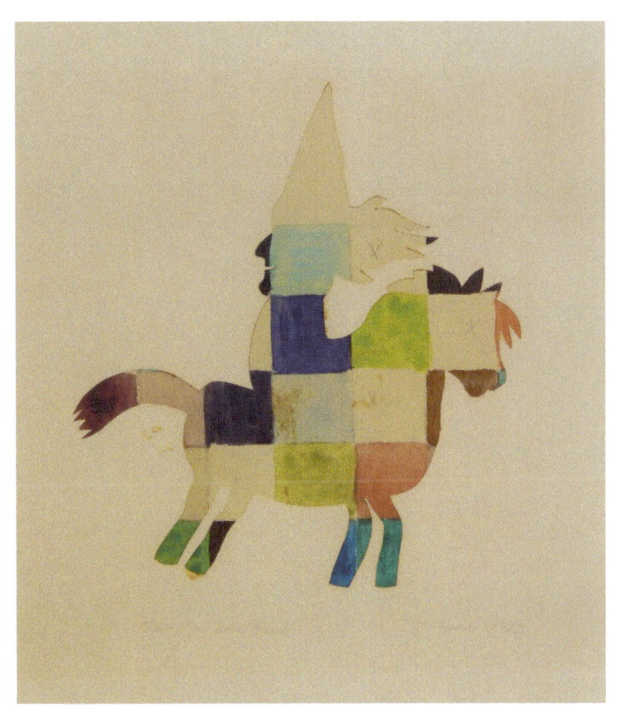

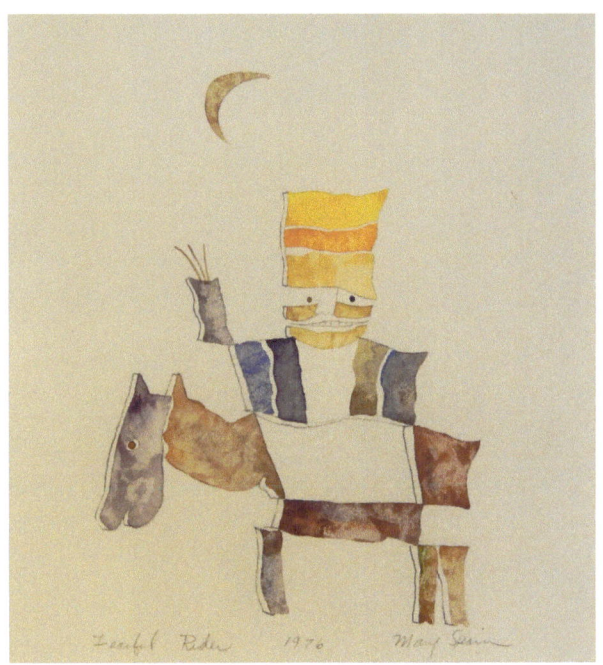

Fearful Rider, 1976
Watercolor and graphite on paper, 9 x 8 in.
Collection of Jean and Paul Ingalls

Clown on Horseback, 1972
Watercolor, graphite and cut paper on paper, 9 x 8.25 in.
Collection of Jean and Paul Ingalls

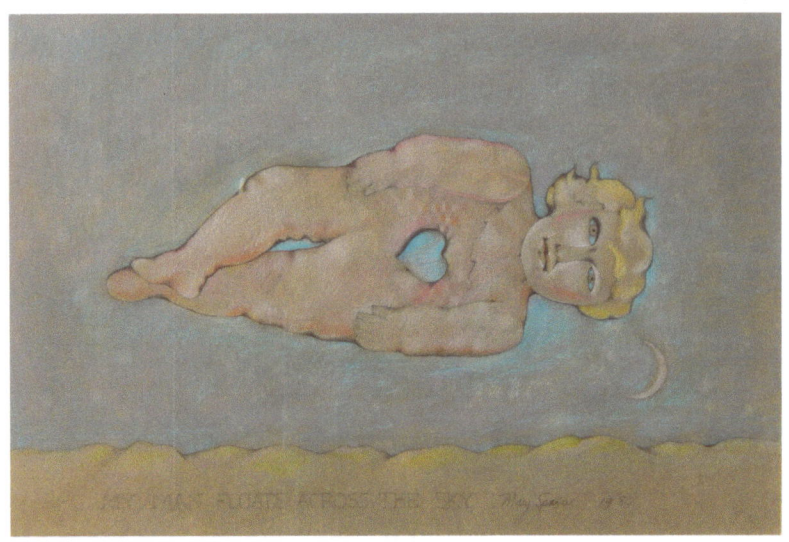

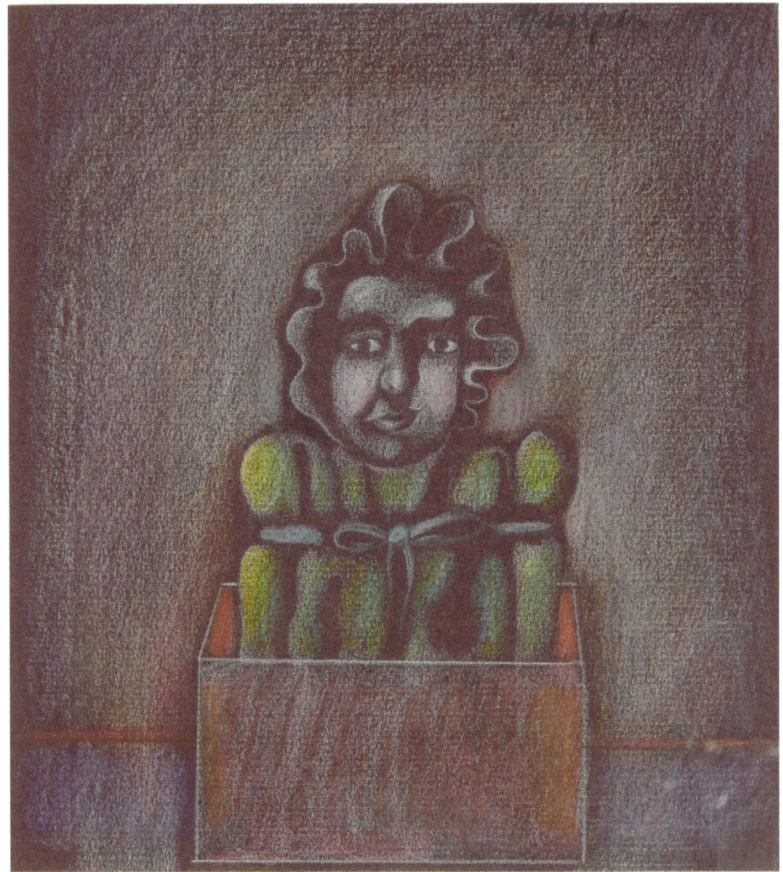

My Man Floats Across the Sky, 1980
Pastel and graphite on paper, 10 x 15.25 in.
Collection of Betsy Colie and Tim Gleason

Little Girl in a Box, 1981
Pastel on paper, 6.5 x 6 in.
Collection of Heidi Robb

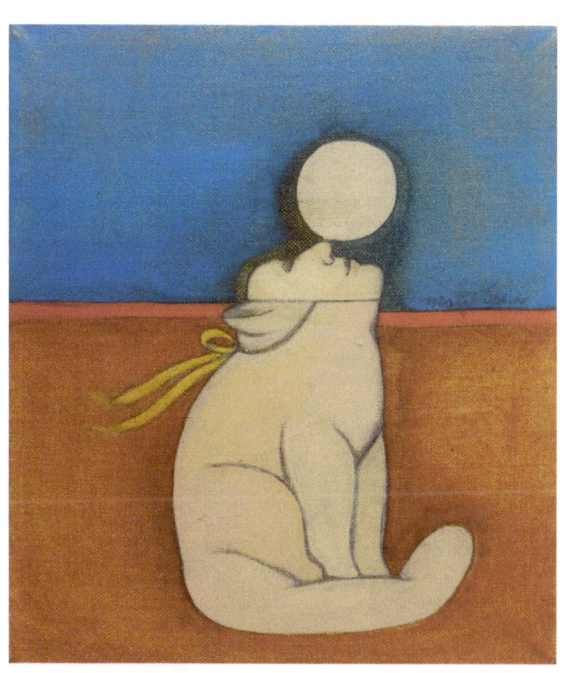

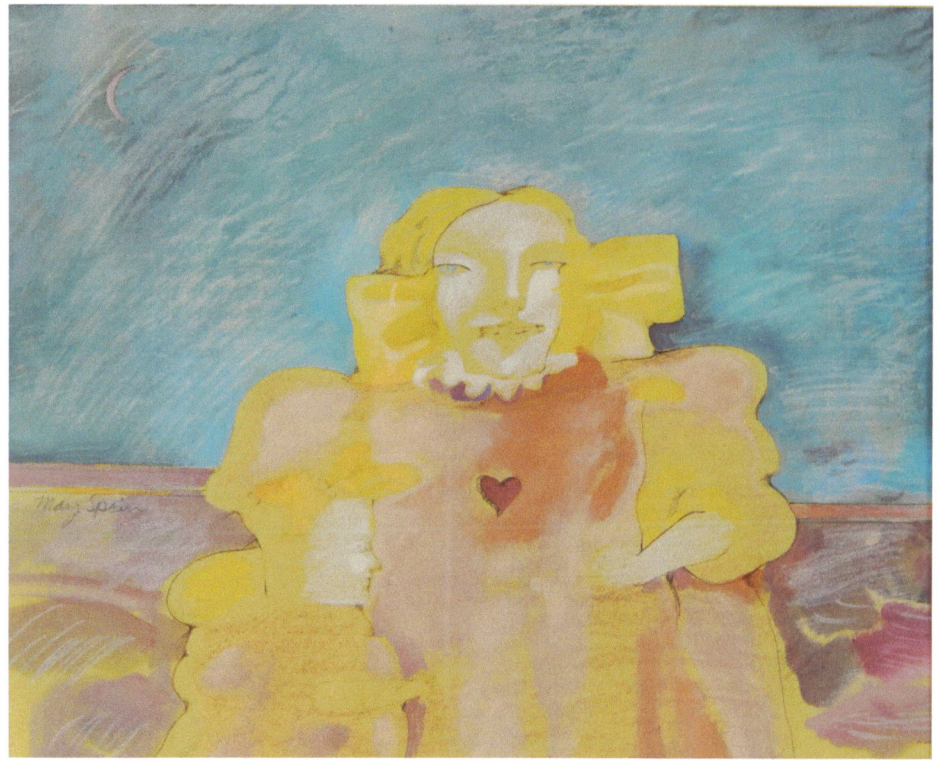

Cat Balancing the Moon on His Nose, 1982
Oil and graphite on canvas, 9 x 8 in.
Collection of Betsy Colie and Tim Gleason

2 Sisters, 1970s
Watercolor and pastel on paper, 11 x 14 in.
Collection of Betsy Colie and Tim Gleason

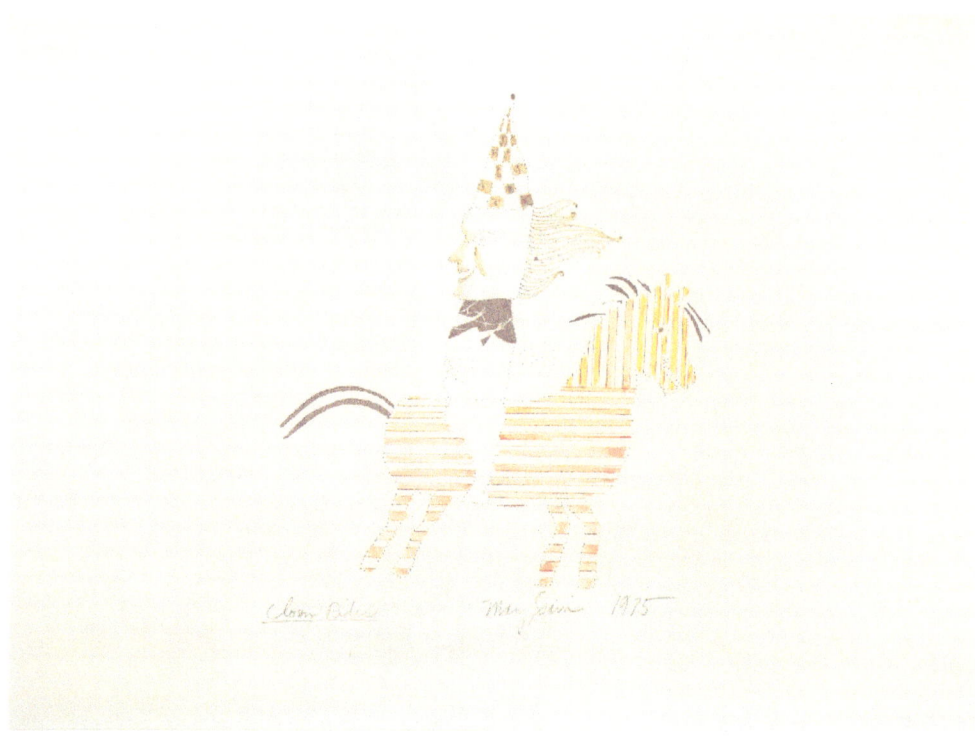

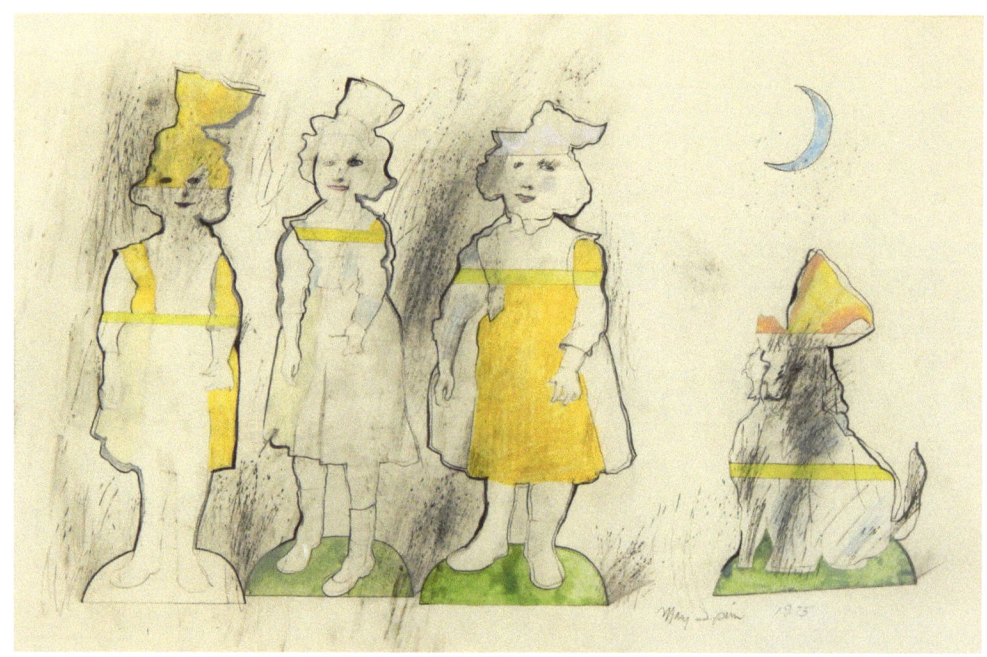

Clown Rider, 1975
Colored pencil and graphite on paper, 9.75 x 13.75 in.
Gift of Joseph Erdelac, AN1994-324

3 Little Stand Up Girls with their Dog, 1975
Watercolor and graphite on paper, 11 x 17.5 in.
Collection of Betsy Colie and Tim Gleason

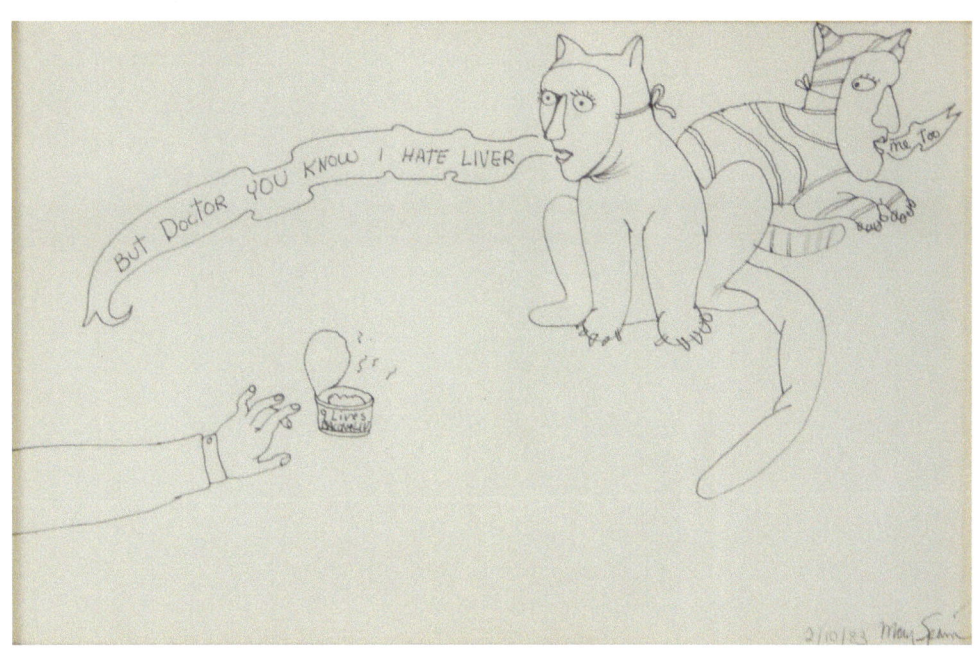

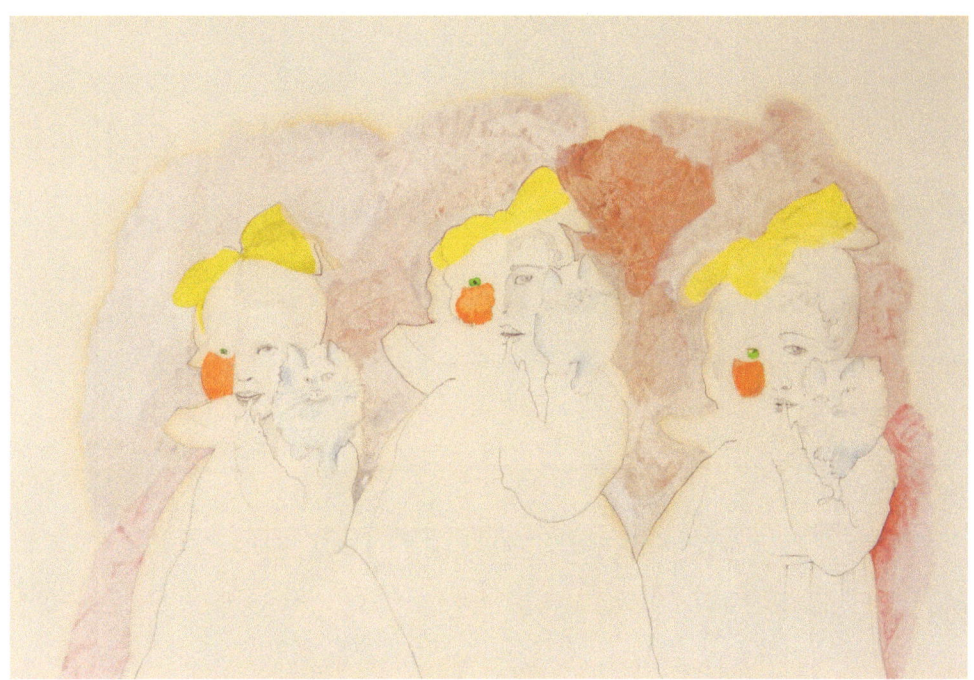

But Doctor, You Know I Hate Liver, 1983
Pen and ink on paper, 5 x 8 in.
Collection of Heidi Robb

3 Girls and Their Cats, 1970s
Gouache and graphite on paper, 11 x 16.5 in.
Collection of Heidi Robb

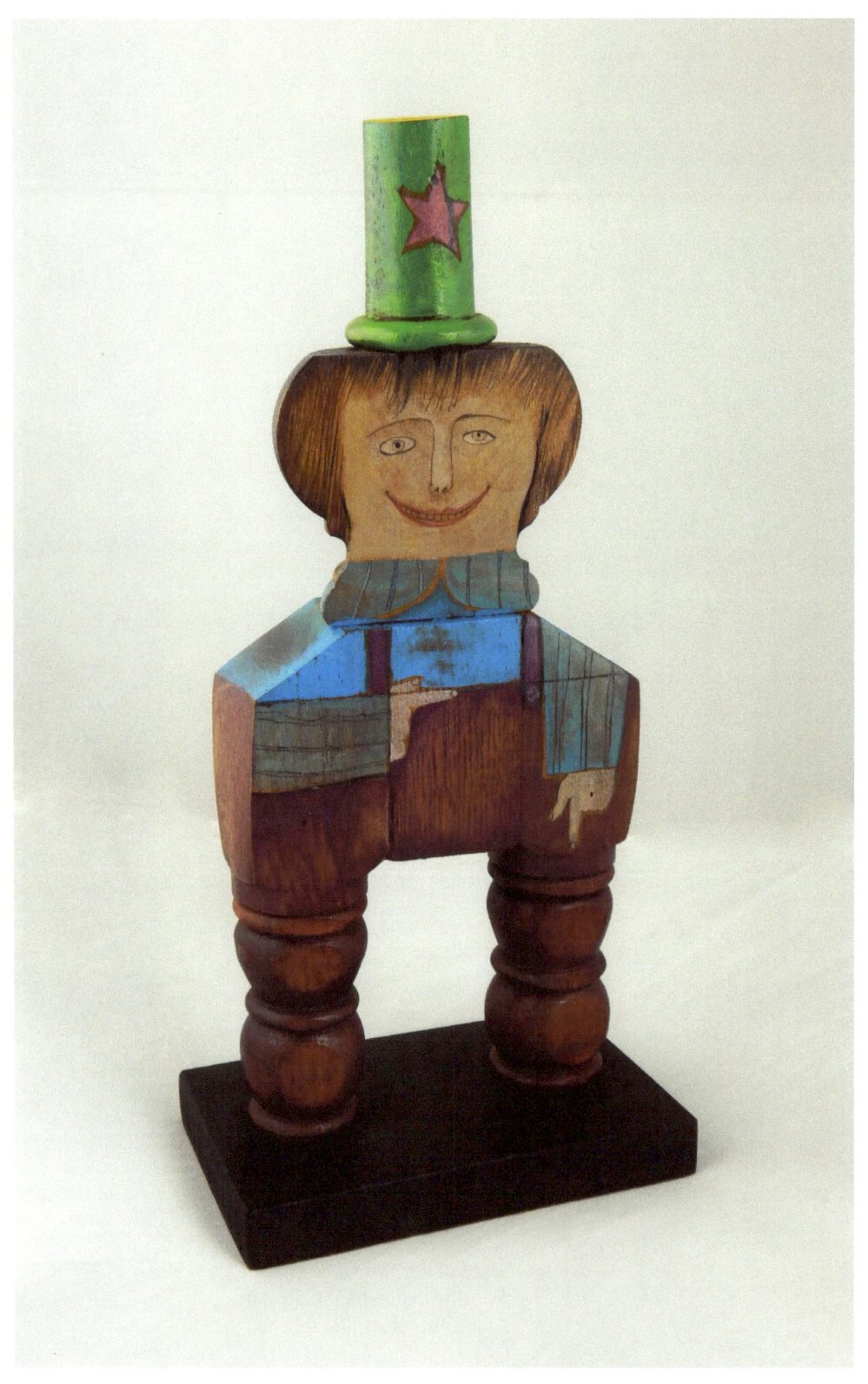

The Ornamental Man, 1970s
Acrylic on wood assemblage, 12.5 x 6 x 3.5 in
Canton Museum of Art Collection

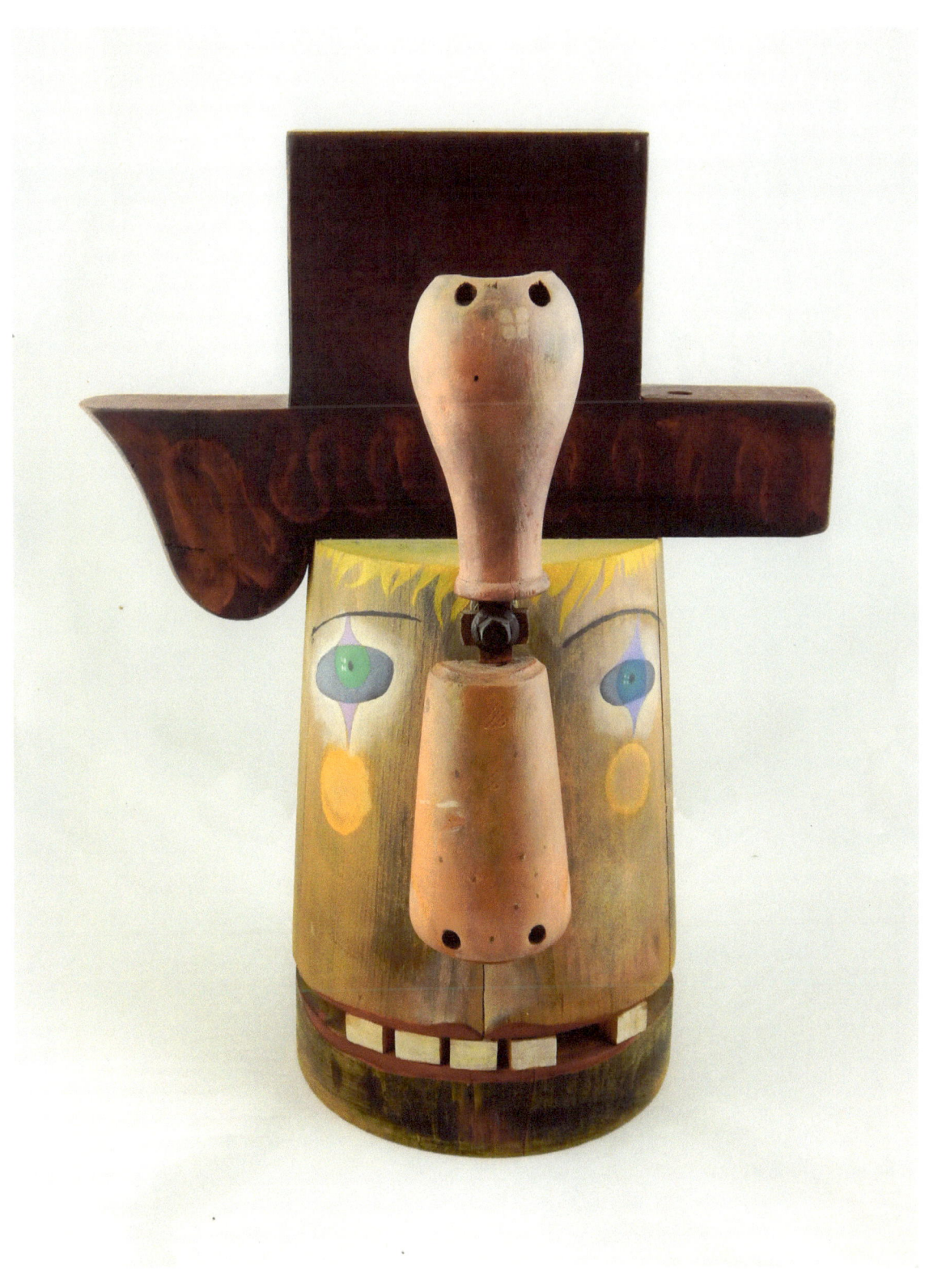

Squeaky, 1970s
Acrylic on wood assemblage, 15.5 x 12.5 x 10 in.
Courtesy of Rachel Davis Fine Arts

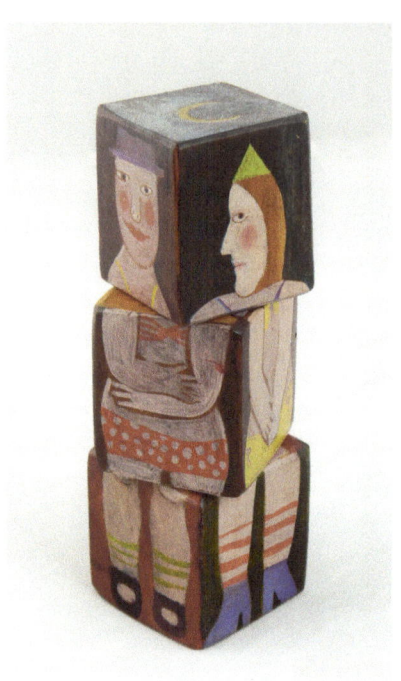

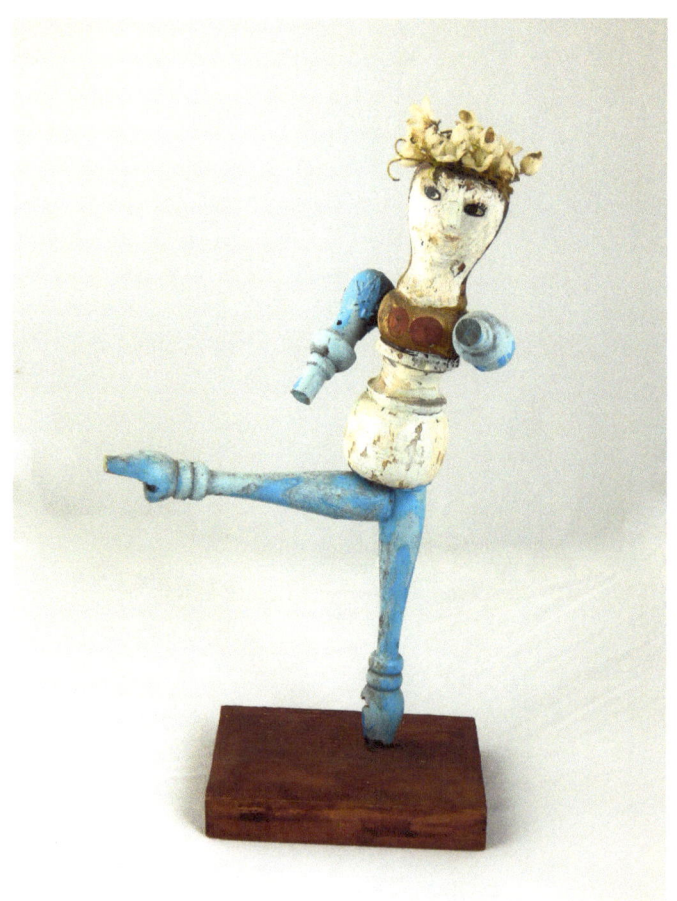

Untitled, 1970s
Acrylic on wood, 5.5 x 1.75 x 1.75 in
Collection of Betsy Colie and Tim Gleason

The Dancer, 1967
Acrylic on wood assemblage, 12 x 7 x 4 in.
Collection of Jean and Paul Ingalls

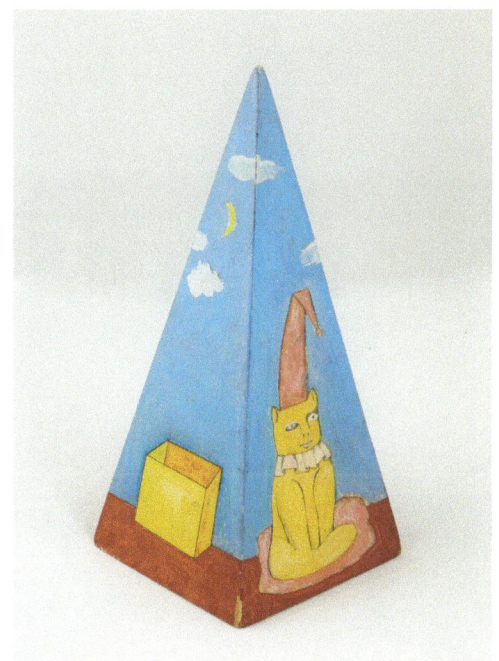
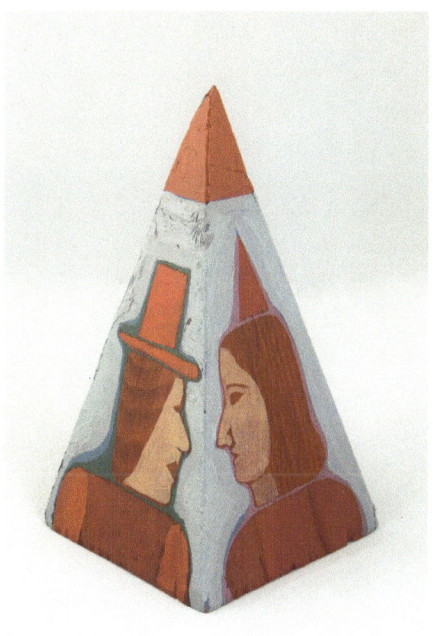
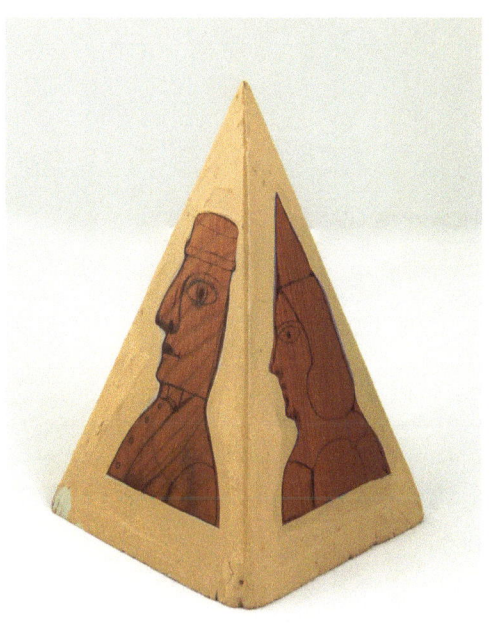
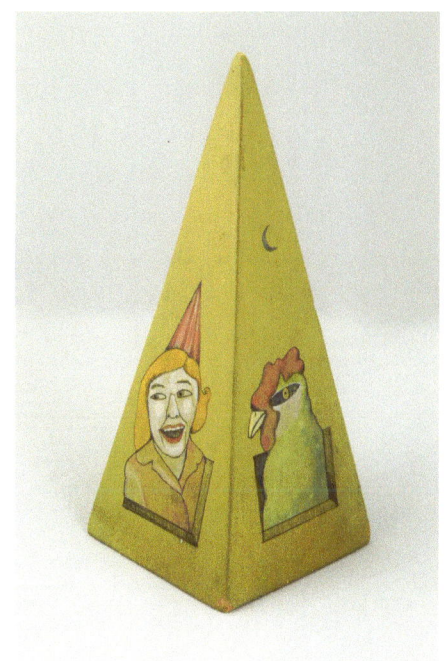

Cat and Ball and Ladder and a Box, 1982
Acrylic and graphite on wood, 7.5 x 3.5 x 3.5 in.
Collection of Betsy Colie and Tim Gleason

Untitled, 1970s
Acrylic on wood, 6 x 4 x 3.5 in.
Collection of Jeff and Cheryl Schug

4 Red Heads, 1970s
Acrylic on wood, 6.5 x 3.5 x 3.5 in.
Collection of Jeff and Cheryl Schug

A Non-Golden Goose Egg, Me and a Chicken, and Handsome Gentleman, 1982
Acrylic on wood, 8 x 3.25 x 3.25 in.
Courtesy of Rachel Davis Fine Arts

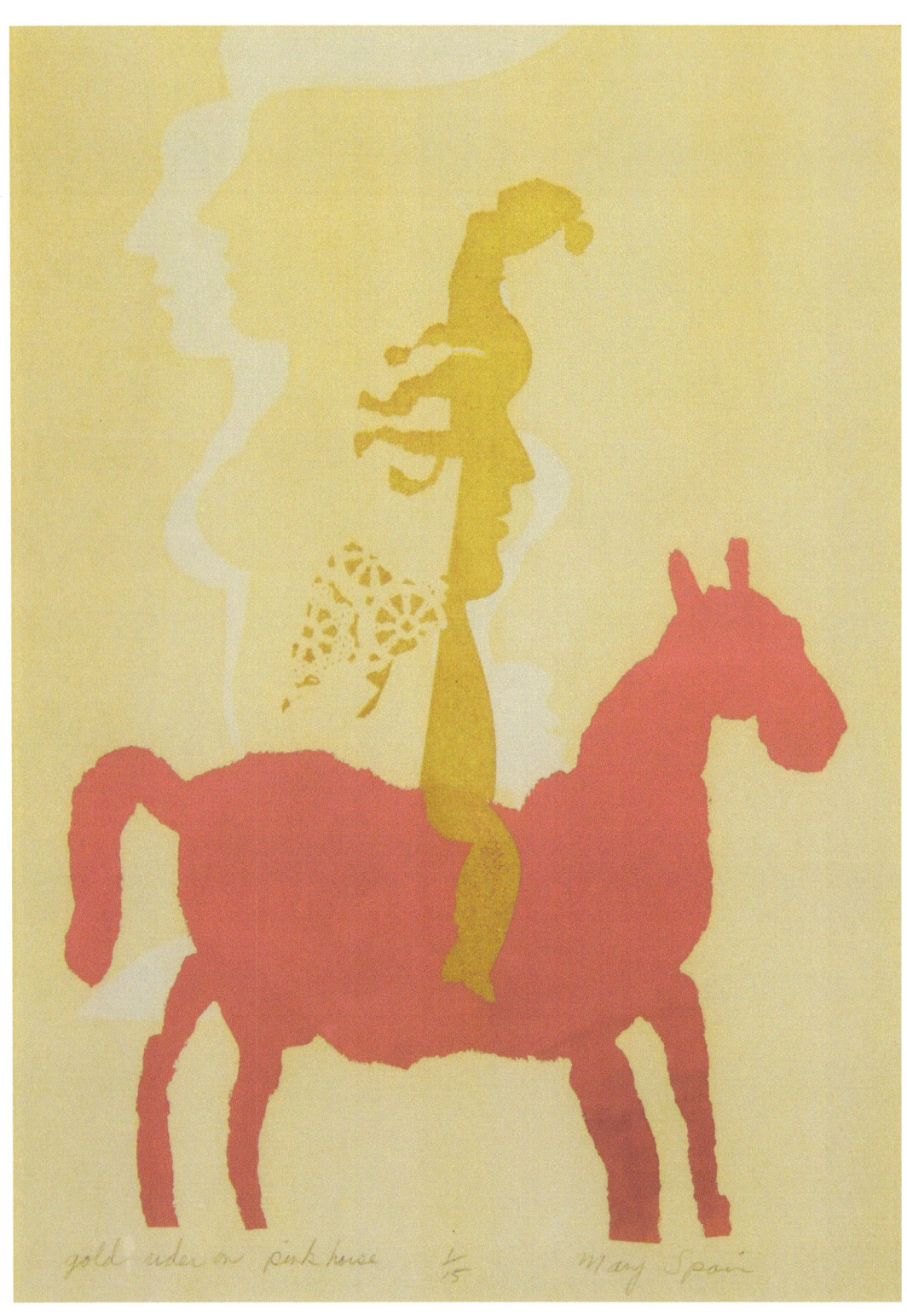

Gold Rider on Pink Horse, 1970s
Acrylic and ink relief print, 12.5 x 9 in.
Collection of Jean and Paul Ingalls

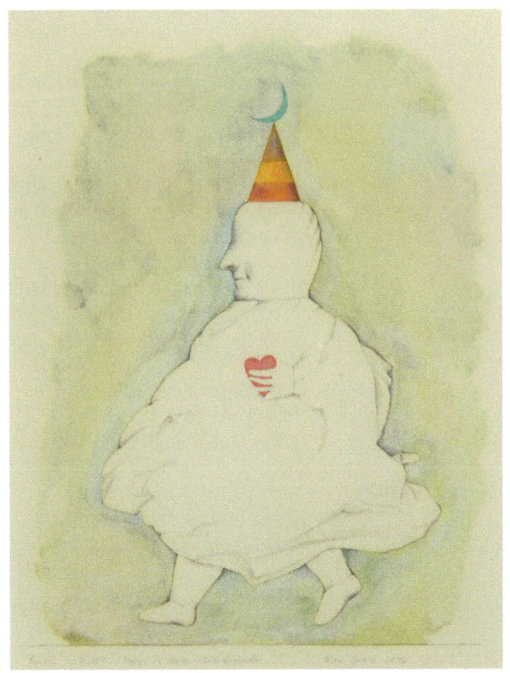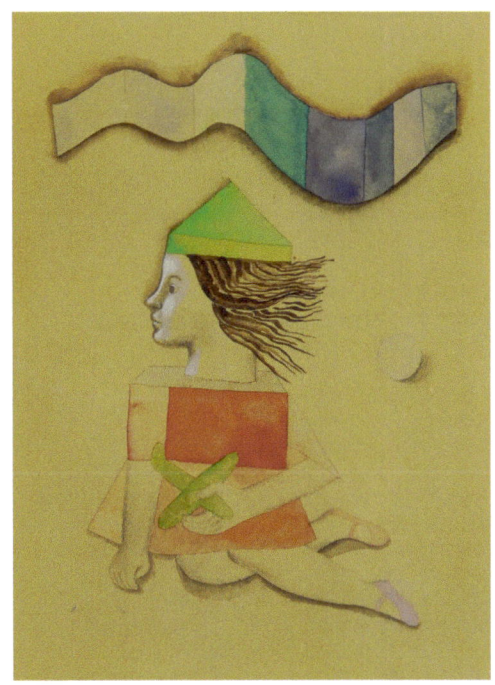
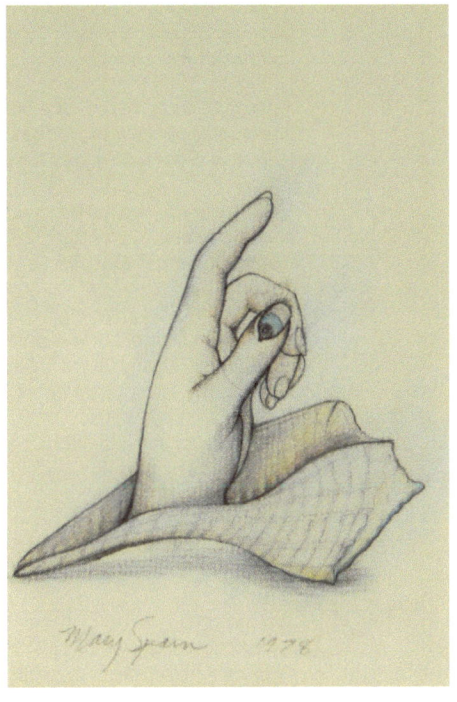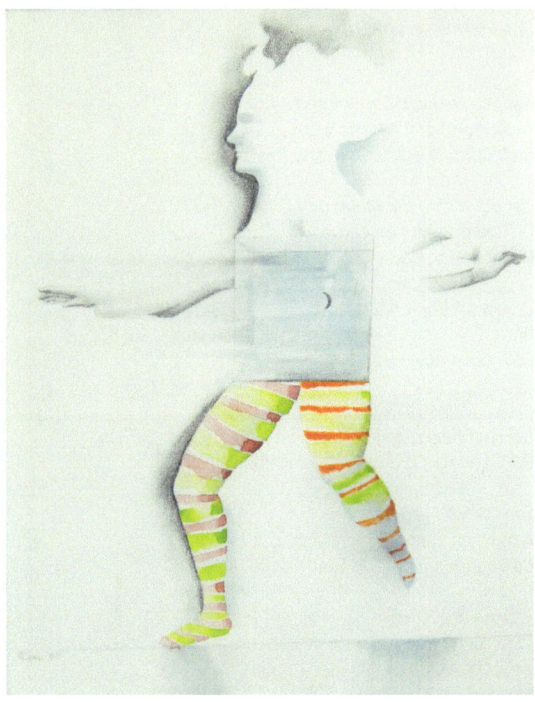

Happy is the One Who Finds Wisdom, 1979
Watercolor and graphite on paper, 12 x 9 in.
Collection of Heidi Robb

Girl with a Green Airplane, 1970s
Watercolor and graphite, 16 x 12 in.
Collection of Jenny Gibson

Seashell, 1978
Colored pencil and graphite, 6 x 4 in.
Collection of Heidi Robb

Untitled, 1970
Watercolor and graphite on paper, 20 x 16 in.
Collection of Jean and Paul Ingalls

Exhibition Checklist

2 Sisters, 1972
Oil on canvas, 35 x 48 in.
Collection of Heidi Robb

2 Sisters, 1970s
Watercolor and pastel on paper, 11 x 14 in.
Collection of Betsy Colie and Tim Gleason

3 Girls and Their Cats, 1970s
Gouache and graphite on paper, 11 x 16.5 in.
Collection of Heidi Robb

3 Little Stand Up Girls with their Dog, 1975
Watercolor and graphite on paper, 11 x 17.5 in.
Collection of Betsy Colie and Tim Gleason

4 Red Heads, 1970s
Acrylic on wood, 6.5 x 3.5 x 3.5 in.
Collection of Jeff and Cheryl Schug

A Non-Golden Goose Egg, Me and a Chicken, and Handsome Gentleman, 1982
Acrylic on wood, 8 x 3.25 x 3.25 in.
Courtesy of Rachel Davis Fine Arts

Boy with a Mechanical Cat, 1981
Oil on canvas, 36 x 40 in.
Courtesy of Rachel Davis Fine Arts

But Doctor, You Know I Hate Liver, 1983
Pen and ink on paper, 5 x 8 in.
Collection of Heidi Robb

Cat and Ball and Ladder and a Box, 1982
Acrylic and graphite on wood, 7.5 x 3.5 x 3.5 in
Collection of Betsy Colie and Tim Gleason

Cat Balancing the Moon on His Nose, 1982
Oil and graphite on canvas, 9 x 8 in
Collection of Betsy Colie and Tim Gleason

Clown on Horseback, 1972
Watercolor, graphite, and cut paper on paper, 9 x 8.25 in.
Collection of Jean and Paul Ingalls

Clown Rider, 1975
Colored pencil and graphite on paper, 9.75 x 13.75 in.
Gift of Joseph Erdelac, AN1994-324

The Dancer, 1967
Acrylic on wood assemblage, 12 x 7 x 4 in.
Collection of Jean and Paul Ingalls

Fearful Rider, 1976
Watercolor and graphite on paper, 9 x 8 in.
Collection of Jean and Paul Ingalls

Girl with Fan and Butterfly, 1970s
Acrylic on canvas, 16 x 18 in.
Collection of Heidi Robb

Girl with a Green Airplane, 1970s
Watercolor and graphite, 16 x 12 in.
Collection of Jenny Gibson

Girl with Horse at Window, 1970s
Oil on canvas, 40 x 48 in.
Courtesy of Rachel Davis Fine Arts

Girl Tossing Purple Petunias in Her Dress, 1982
Oil on canvas, 36 x 40 in.
Collection of Jon and Rochelle Straffon

Gold Rider on Pink Horse, 1970s
Acrylic and ink relief print, 12.5 x 9 in.
Collection of Jean and Paul Ingalls

Hanging Clown with Yellow Cat, 1970s
Oil and graphite on canvas, 25.5 x 29.5 in.
Canton Museum of Art Collection

Happy is the One Who Finds Wisdom, 1979
Watercolor and graphite on paper, 12 x 9 in.
Collection of Heidi Robb

Heidi and Steve Playing Cards, 1970s
Oil and graphite on canvas, 36 x 44 in.
Collection of Jean and Paul Ingalls

Little Girl in a Box, 1981
Pastel on paper, 6.5 x 6 in.
Collection of Heidi Robb

Man and Woman Playing Ball with the Moon, 1970s
Oil on canvas, 48 x 54 in.
Courtesy of Wolfs Gallery

Man Hanging Upside Down *and Amaryllis*, 1982
Oil on canvas, 36 x 42 in.
Collection of Betsy Colie and Tim Gleason

Magician and 2 White Parrots, 1970s
Oil and graphite on canvas, 36 x 40 in.
Courtesy of Wolfs Gallery

My Man Floats Across the Sky, 1980
Pastel and graphite on paper, 10 x 15.25 in.
Collection of Betsy Colie and Tim Gleason

The Ornamental Man, 1970s
Acrylic on wood assemblage, 12.5 x 6 x 3.5 in.
Canton Museum of Art Collection

Rag Man, 1974
Oil, graphite and collage on canvas, 40 x 36 in.
Collection of Jeff and Cheryl Schug

Seashell, 1978
Colored pencil and graphite, 6 x 4 in.
Collection of Heidi Robb

Squeaky, 1970s
Acrylic on wood assemblage, 15.5 x 12.5 x 10 in.
Courtesy of Rachel Davis Fine Arts

Untitled, 1970
Watercolor and graphite on paper, 20 x 16 in.
Collection of Jean and Paul Ingalls

Untitled, 1970s
Acrylic on wood, 5.5 x 1.75 x 1.75 in.
Collection of Betsy Colie and Tim Gleason

Untitled, 1970s
Acrylic on wood, 6 x 4 x 3.5 in.
Collection of Jeff and Cheryl Schug

Woman in Flight, 1973
Acrylic on canvas, 14 x 17.5 in.
Collection of Heidi Robb